PAUL KLEE

Life and Work

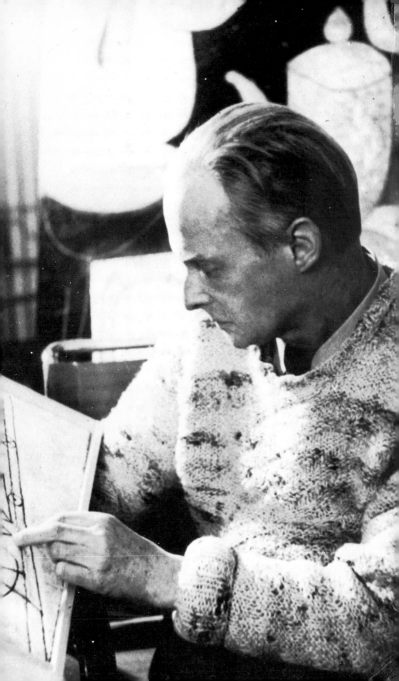

PAUL KLEE

Life and Work

By Christian Geelhaar

Translated by W. Walter Jaffe

Woodbury, N.Y. • London • Toronto

Front Cover: Paul Klee, *New Harmony,* 1936
Back Cover: Paul Klee, *Limits of the Intellect,* 1927

For Max Hoggler on his seventieth birthday

First U.S. edition published in 1982 by Barron's Educational Series, Inc.

Originally published and © copyrighted in German language in 1974 by M. DuMont Schauberg, Cologne.

All rights for all countries reserved by Andreas Landshoff Productions, Amsterdam.
The title of the German edition is:
PAUL KLEE
Leben und Werk
by Christian Geelhaar

All inquiries should be addressed to:
Barron's Educational Series, Inc.
113 Crossways Park Drive
Woodbury, New York 11797

Library of Congress Catalog Card No. 81-19052
International Standard Book No. 0-8120-2186-0

Library of Congress Cataloging in Publication Data

Geelhaar, Christian.
 Paul Klee, life and work.

 Bibliography: p. 102
 1. Klee, Paul, 1879-1940. 2. Painters—Germany—
Biography. I. Klee, Paul, 1879-1940. II. Title.
ND588.K5G4213 759.9494 [B] 81-19052
ISBN 0-8120-2186-0 AACR2

PRINTED IN HONG KONG

2345 041 987654321

Contents

List of Illustrations

Note Re Photograph Captions.
After the title of the work, two sets of numbers are presented. The first number indicates the year in which the work was executed; the second number indicates the artist's sequential record for each year's output.

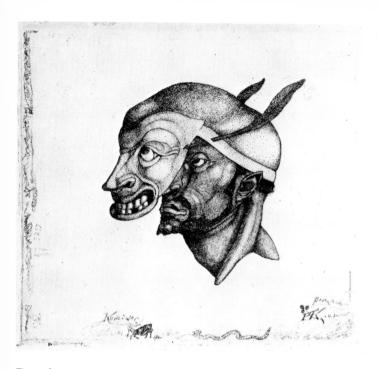

Figure 1
Comedian, 1904/10
Etching,
14.6 x 16 cm,
Paul Klee
Foundation,
Bern

Introduction

The twenty-four year old Paul Klee considered the etching *Comedian*—the fourth of the eleven "Inventions" that the artist collected under the title "Opus One"—to be his "most personal work" up to that time. By contrasting the grotesquely humorous mask with the tragically serious human face behind it, Klee was attempting for the first time to bring about the artistic reconciliation of complementary dimensions that he would programatically call for in his diary in 1917: "The demoniacal shall be melted into simultaneity with the celestial, the dualism shall not be treated as such, but in its complementary oneness. For truth asks that all elements be present at once."

The need to experience the universe in its cohesiveness and the striving to actualize such

a totality through the plastic arts manifested itself early in Klee's life. "An observer above the world or a child in the world's totality:" in this way, Klee, at twenty-six years of age, recorded in his diary how he perceived the first non-conflicting moment of his life. His ironic perspective of the world allowed him to distance himself from the limitations of existence: earthly antitheses and conflicts lost their tragic value. Good and evil, rather than being viewed as hostile forces, were regarded as effective solely in terms of their dialectical simultaneity: "Evil should not be an enemy who triumphs or who shames us, but a power contributing to the whole. A part of conception and development. The primordial-masculine (evil, stimulating, passionate) and primordial-feminine (good, growing, tranquil) together producing a state of ethical stability."

But the "most penetrating understanding of the way these things work together in the universe" is of no use to the artist if he does not possess the essential equipment for pictorial representation. With unusual persistency, Klee sought to systematically acquire the necessary instruments of composition. As a gifted violinist, he gleaned crucial insights from his musical experience. In 1905 he had not yet succeeded in thoroughly investigating the analogies between music and the plastic arts, yet he was convinced that "certainly both arts are temporal; this could be proved easily." It was in music that Klee first became aware of the principle of spatial and temporal rhythm, a principle that he would transfer to painting. His theory of art and esthetics was dynamic: the work of art

emerges from the movement of the hand, is in itself fixated movement, and is received through the movement of the spectator's eye.

Klee's complex view of the world, that is, his endeavor "To be able to reconcile the opposites! To express the great manifold in a single word!" finds its analogy within the plastic arts in a "simultaneous union of forms, movement, and countermovement, or to put it more naively, of objective contrasts. Every energy requires its complement to bring itself to rest outside the field of force." As a painter, Klee learned how to visually orchestrate this synthesis by turning to polyphonic music. Polyphony is defined as the synchronous intonation of several independent voices. The technique of polyphonic composition was perfected by Johann Sebastian Bach and Mozart, whose work and creative methods served as Klee's most prominent models.

During his youth, Klee could not decide for a long time whether to become a musician or a painter. His commitment to the plastic arts was determined by his view that painting had not yet attained the absolute level of development that Mozart had achieved in music. "What a fascinating fate it is to master painting today (as it once was to master music)," Klee asserted in 1918; he believed that it was first of all a question of recovering lost ground. Klee directed himself "to gather insights into music through the special character of polyphonic works, to penetrate deep into this cosmic sphere, to issue forth a transformed beholder of art, and then to lurk in waiting for these things in the picture." A decade later Klee could state in his essay

"Exact Experiments in the Realm of Art," which summarized his work up to that time, "What was accomplished in music before the end of the eighteenth century has hardly begun in the pictorial field."

Klee's later comments on the etching *Comedian* offer further information concerning his attitudes about his life and himself: "One more thing may be said about the *Comedian*: the mask represents art, and behind it hides man. The duality of the world of art and that of men is organic, as in one of Johann Sebastian's compositions." In fact, Klee sought to unify his work and humanity with astoundingly logical consistency, and recognized that human clarity was the necessary basis of his creative work. The twenty-two year-old considered "the art of mastering life" to be the "prerequisite for all further forms of expression, whether they are paintings, sculptures, tragedies or musical compositions. Not only to master life in practice, but to shape it meaningfully within me [Klee] and to achieve as mature an attitude before it as possible." In looking back, Klee consciously linked certain stages of his professional growth to external events in his life. By the end of World War I, Klee's creative work had become the purpose of his existence. He abandoned the diary he had kept since 1898. Whatever transpired within Klee as a human being—the content of his feelings and internal experiences—was recorded from that time on in his drawings and paintings. In the painting *Actor's Mask,* the duality of human being and mask that characterized the etching *Comedian* has been invalidated and transformed into a mask of the artist's own self-portrait.

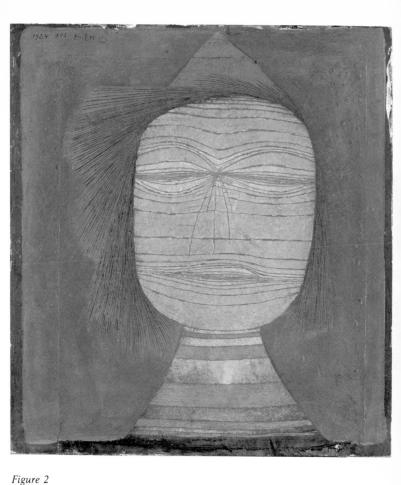

Figure 2
Actor's Mask,
1924/252
Oil on canvas,
36.4 x 36.4 cm,
The Museum of
Modern Art,
New York, The
Sidney and Harriet
Janis Collection

5

Figure 3
Paul Klee,
Bern, 1896

Klee's Isolation

Paul Klee was born on December 18, 1879 in Münchenbuchsee, near Bern (Switzerland). His father, Hans Klee, who came from Unterfranken, taught music and voice at the State Teacher's College in Hofwil. His mother, Ida Frick, a Swiss citizen born in Besançon, had studied in Stuttgart to become a singer. Klee spent his youth in Bern, where his parents settled in 1880. His maternal grandmother encouraged him to draw and color at a very early age. At the age of nine, Klee became fascinated with the marble tables in his uncle Ernst Frick's restaurant; he could see in the speckled surface in the veins of the marble grotesque human figures, which he could trace with a pencil. It was at this stage in Klee's life that his "bent for the bizarre" (as he himself expressed it) first manifested itself. While visiting his violin teacher, the distinguished music professor and concertmaster Karl Jahn, the boy found the opportunity to leaf through art books. His rapid progress on the violin soon allowed him to perform as an associate member of the city orchestra. Yet when the question of becoming a painter or musician arose prior to his university entrance exam, Klee decided in favor of painting.

In October 1898 Klee began his three-year study program in Munich, first under Heinrich Knirr, and then, in the winter of 1900-1901, under Franz von Stuck at the Academy. Klee showed signs of serious commitment only during the final year of his training. He observed in his diary in 1901, "That my

*Figure 4, 5
Details from
Comedian, 1904*

betrothal [to the pianist Lily Stumpf] should coincide in time with this state is perfectly logical."

Klee's years of study concluded with a fairly long trip to Italy between October 1901 and May 1902, "in order to fill in the gaps." Genoa, Rome, Naples, and Florence offered Klee a living history lesson, followed by a period of "great perplexity." The thought "of having to live in an epigonic age" was a "great humiliation," which he withstood by means of self-irony and bitter satire.

After returning home to his parents in Bern, Klee produced a series of etchings between 1903 and 1906, including *Virgin in a Tree,*

Woman and Animal, Comedian, and *The Hero with the Wing.* The literary content of these works can be understood in terms of Klee's annoyance with and scorn of society and bourgeois conventions. Yet such political views also carry with them a personal, confessional element—as demonstrated by the example of the *Comedian.*

Klee created the eleven "Inventions" without directly studying nature; rather, he freely applied the knowledge of human anatomy which he had acquired while drawing nude models. Evidence of his inner mastery and liberated technique are his test-strokes and marginalia: one example, in the *Comedian,* is a crowned snake hypnotizing a frog.

The first successful realization of Klee's artistic intention can be found in "Opus One." To be sure, these etchings are still indebted to the symbolism of the *fin-de-siècle* and *Jugendstil,* as becomes apparent in the detail of the clover leaf [*Klee-Blatt:* a pun on the artist's name] twisted through the initials PK. But the artist could well content himself with the fact that his "own natural bent" nurtured these works.

The so-called "classical" mode of these etchings is continued in the *Portrait of My Father* of May 1906, which, unlike the freely improvised "Inventions," is drawn "from life." Klee was successful at last in his attempt to convert an impression of nature into a personal style. In Klee's own words, "still another limitation has been broken and, at that, the heaviest, hardest limitation there is for an artist." Such inner progress encouraged him to risk a change, even in external matters, for in September 1906 Klee married and moved to Munich.

Figure 6
Portrait of My
Father, 1906/23
Glass painting,
32 x 29 cm,
Felix Klee
Collection, Bern

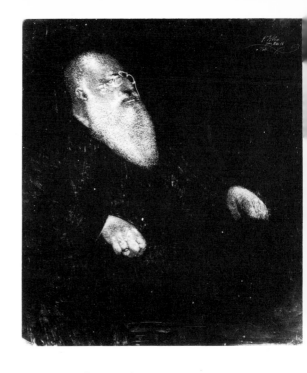

Portrait of My Father is scratched with a needle on a blackened pane of glass. "The medium is no longer the black but the white line. The white energy on a nocturnal ground beautifully corresponds to the phrase 'Let there be light.' I thus softly glide into the new world of tonalities."

Klee's exposure to French Impression during his first trip to Paris in June 1905 greatly inspired his methodical investigation of light effects—*chiaroscuro*. As soon as Klee turned to the Impressionist manner of observation and painting, he abandoned the epigrammatic and hypothetical themes of his early etchings

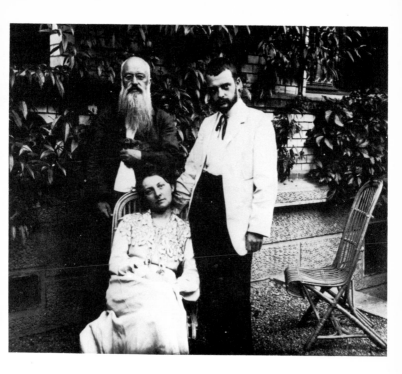

Figure 7
Hans, Lily and
Paul Klee, Bern,
September 1906

and focused expressly on natural phenomena.

As a "modest, ignorant, self-taught man," Klee had, in his early etchings, begun to appropriate the use of artistic tools suitable for him. Through painstaking, minutely detailed work on the copperplate, Klee had tested the pictorial effectiveness and expressive possibilities of the point and the line. He classified the scratched-glass drawings as a "transition from the graphic to the pictorial state." The needle then gave way to the paintbrush, and by using it loosely on the smooth glass surface the artist conquered the medium of painting.

11

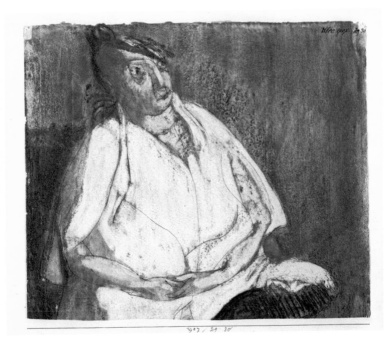

Klee's use of the charcoal pencil aided in his
study of tonal values. In the charcoal drawing
Portrait of a Woman, which depicts Lily Klee
a few weeks before the birth of her son Felix,
the *chiaroscuro* is enlivened by the sparing
application of watercolor accents.

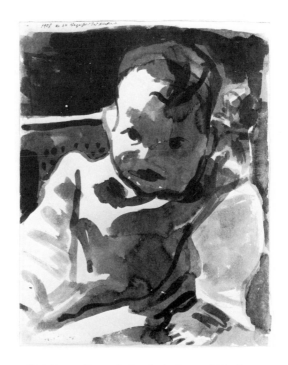

Figure 9
Child's Portrait,
1908/64
Black watercolor,
30 x 24 cm,
Felix Klee
Collection, Bern

Yet it was through the technique of black watercolor that Klee strictly maintained every tonal progression from white to black. Leaving white space for the highlights, Klee applied black watercolor layer by layer and gradually moved into shadowy darkness as in the *Child's Portrait (Felix)*.

Figure 10
Flower Stand,
Watering Can,
and Pail,
1910/47

Watercolor,
13.7 x 12.3 cm,
Städtische Galerie,
Munich

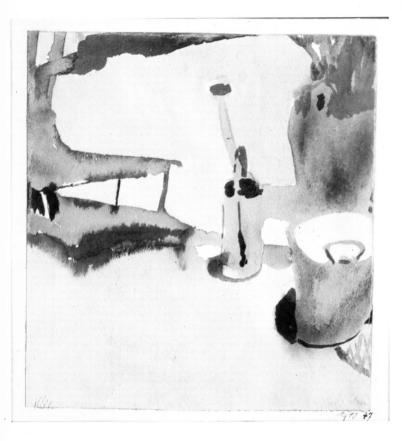

In 1910 the painter transferred the "*chiaroscuro* time-measuring process" to the use of colors. In this process a different color corresponds to each individual tonal level, as in *Flower Stand, Watering Can, and Pail.*

The impressionistic study of nature restrained Klee's "capacity for linear treatment," which he felt more and more strongly compelled to master. He saw in Vincent van Gogh's work the model of a line "that benefits from Impressionism and at the same time conquers it." His preoccupation with van Gogh resulted in "mediation experiments with the outside world," to which, according to Klee, belongs his self-portrait, *Young Man Resting.*

Klee knew that his "real personality" would again have a chance to speak if he was able to enter his "prime realm of psychic improvisation again," which he had forsaken with the etchings of 1903-06, "to note experiences that can turn themselves into linear compositions even in the blackest night." Klee's favorite book, *Candide,* permitted the rediscovery of his "actual self." In his diary of 1906 he had emphasized the significance of Voltaire's novel for his ironic world view with three exclamation marks. Klee's plan to furnish each chapter of *Candide* with an illustration dated from 1909, and he spent much of 1911 and 1912 carrying out this self-imposed task.

Figure 11
Young Man
Resting, 1911/42
Tusche applied
with paintbrush,
14 x 10.2 cm,
Private
collection, Bern

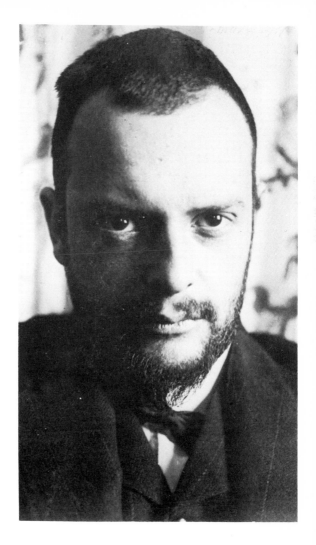

17

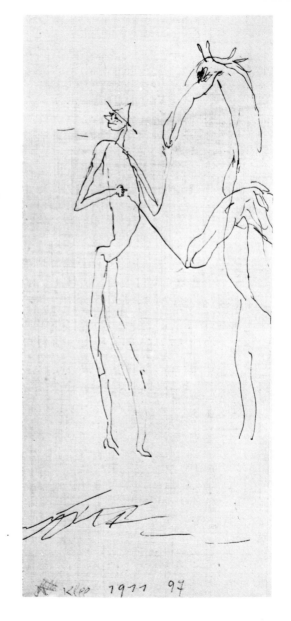

*Figure 13
Cacambo with
the Horses,
1911/97
Pen drawing,
15.2 x 6.5 cm,
Paul Klee
Foundation, Bern*

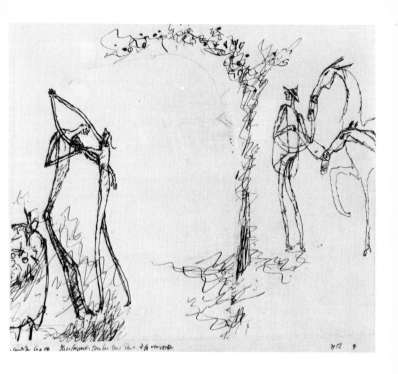

Figure 14
Ils se laissent
tomber tous deux
à la renverse
(Candide,
chapter 14),
1912/9
Pen drawing,
18.7 x 22.5 cm,
Paul Klee
Foundation, Bern

The "exquisitely spare and exact expression of the Frenchman's style," so admired by Klee, finds its congenial parallel in a bold drawing style that dissolves corporeality into a burlesquely animated and expressive flow of lines. If we compare the sketch *Cacambo with the Horses* to the illustration for chapter 14 of *Candide, Ils se laissent tomber tous deux à la renverse*, it becomes clear how much Klee as a draftsman sought to preserve the spontaneity of his initial, improvised (as it were) ideas.

Assimilation into Artistic Society

This period of solitary endeavor came to an end in 1911 when Klee emerged from his self-imposed isolation and associated himself with like-minded individuals. In January he had the satisfaction of being visited by Alfred Kubin. Through Louis Moilliet, an artist colleague from Bern, Klee became acquainted with August Macke in the summer of 1911, and in the fall of that same year occurred the fateful meeting with the founders of the "Blue Rider" artists' collective, Vassily Kandinsky and Franz Marc. Along with Paris, Munich was the leading artistic center in Europe at that time. It was there that Klee, while visiting various exhibitions, was introduced to such revolutionary European artistic movements as Fauvism, Cubism, and Futurism.

Paris lured Klee once again, and, during a two-week stay, he visited Robert Delaunay in the latter's studio. (Klee's personal meeting with Picasso and Braque took place in Bern in 1937 and 1939 respectively.) While visiting the art dealer Kahnweiler, Klee saw works by Derain, Vlaminck, and Picasso; at Bernheim-Jeune's he saw works by Matisse, and in the collection of Wilhelm Uhde's, paintings by Rousseau, Braque, and Picasso.

It was a time of diverse influences, that largely paved the way for Klee's further creativity. To assess the effect of these pioneering innovations on Klee's own endeavors, one must imagine the task viewed by the twenty-three year old Klee at the end of his Italian trip: "my immediate and at the same time highest goal will be to bring

architectonic and poetic painting into a fusion"; or, in other words, the interplay of strict pictorial construction and personal fantasy. Klee admired the Cubists' structural tension of composition, "the concept of form as a series of dimensions that can be expressed numerically." Kandinsky, however, had boldly opened up new visual and spiritual realms, for he had freed color and line from representational design and had raised them to autonomous instruments of expression. Klee was also indebted to Henri Matisse for discovering the central role of color in modern painting. Finally, Delaunay's Orphism—that is, Cubism in its colorful form—offered Klee crucial insights into the dynamic relationships between simultaneous color contrasts.

Klee required suitable natural subjects in order to put his new knowledge into practice and to awaken dormant painterly skills. He hoped to find such subjects in Tunisia, and traveled there in April 1914 with his friends Louis Moilliet and August Macke. Klee had undertaken the task of "the synthesis of urban architecture and pictorial architecture." Proceeding from nature, he attempted to solidify the constructive framework of his watercolors and, following the Cubist example, divided the pictorial surface into planimetric shapes, i.e., into right angles, squares, triangles, and semicircles. Klee's intention can be elucidated through a comparison of *Hammamet with Mosque* with *Motif from Hammamet*. *Motif from Hammamet* repeats the right half of the first watercolor: the oblique angles running toward the left edge of the picture are a section of the design of crossing diagonals from *Hammamet with Mosque*. Both the blue pinnacle of the central mosque and the wall opening belonging to the

*Figure 15
Hammamet with
Mosque, 1914/199
Watercolor,
20.5 x 19 cm,
Heinz Berggruen
Collection, Paris*

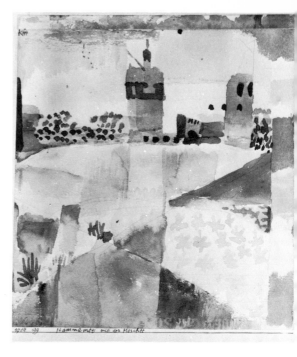

tower on its right can also be diciphered in the
upper third portion of *Motif from Hammamet.*
Landscape and architecture are still
recognizable in *Hammamet with Mosque;* the
contrast of the large surface of colored fields
in the bottom half and of the small areas of
architectural elements at the top simulate a
depth of space. Yet in *Motif from Hammamet,*
Klee totally abandoned topographical details in
favor of a tightly woven, flat architectural
image.

The heightening of abstraction in Klee's
works was accompanied by a clarification of
color relationships. The freely improvised
"chessboard structure" allowed the painter to
balance out and to adjust the coloration in his

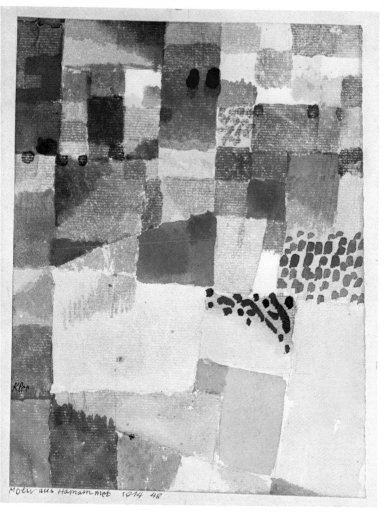

Figure 16
Motif from Hammamet,
1914/48, Watercolor,
20 x 15.5 cm,
Kupferstich-kabinett
[collection], Basel

pictures. The optical and emotional effect of
the hues generates a free-floating harmony;
outward appearance and inward vision, form
and content permeate one another. Klee had
finally discovered the secret of color that he

23

had sought so persistently. On April 16 in
Kairouan he experienced the crucial moment
when he realized that he was a born painter:
"Color possesses me. I don't have to pursue
it. It will possess me always, I know it. That is

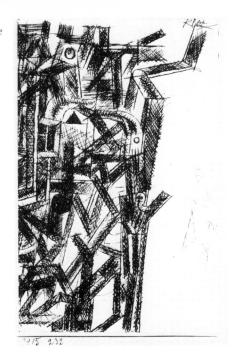

Figure 18
Abstract "High-rise
Architecture,"
1915/232
Fountain
pen drawing,
16.5 x 11 cm,
Felix Klee
Collection, Bern

the meaning of this happy hour; color and I
are one. I am a painter."

With his Tunisian watercolors Klee achieved
an autonomous language of color that would
guide his further work. In 1915 he
disassociated himself totally from any realistic
starting point. He arranged angular, crystalline
forms in a tectonic pictoral framework. As the
titles *Laughing Gothic, Aspiring City Vision,*
and abstract *High-rise Architecture* indicate,
Klee's move toward nonrepresentation was
accompanied by a preoccupation with Gothic
architecture. Klee may have been inspired by
Delaunay's *Saint-Séverin* (1909), a painting he
had seen in the first "Blue Rider" exhibit, by
Rodin's book *Les Cathédrales de France,*

25

*Figure 19
Paul Klee,
Munich, 1916*

which had appeared the previous year, and by
Wilhelm Worringer's theory of the tendency
toward abstraction in the Gothic age, as
postulated in the controversial work *Form in
Gothic* (translated by Herbert Read, Putnam
1927).

World War I broke out in August 1914. Klee's diary of 1915 contains key statements that illuminate his world view and artistic aims. Moreover, these reflections revolve around the theme of "abstraction." Inspired by a maxim of the art theoretician Worringer, Klee pondered, "The more horrible this world (as today, for instance), the more abstract our art, whereas a happy world brings forth an art of the here and now." Political occurrences as outside events were unable to touch Klee's innermost being: "I have long had this war inside me. This is why, interiorly, it means nothing to me. I remain in this ruined world only in memory, as one occasionally does in retrospect. Thus, I am 'abstract with memories.'"

On March 10, 1916, Klee was drafted into the army and trained in Landshut for the infantry. His transfer to the pilots' school in Schleissheim and later to administrative duty in Gersthofen (near Augsburg) allowed more time for his own work. Experiencing the isolation of those war years, Klee expanded his provision of artistic tools to include abstract signs: numbers, letters, exclamation marks, fermatas, arrows—as well as such pictorial, emblematic elements as heavenly bodies, ensigns, eyes, and hearts. In Tunisia, where he was influenced by Islamic art, Klee replaced natural forms for the first time with abbreviated signs such as crosses, arches, gratings, and rows of dots. The sign language Klee adapted from 1917 on rid itself of any association with nature and thus offered the artist unlimited opportunities of expression. Such drawings as *Hieroglyph with the Parasol* and *Embryonic Abstract Elements* have abandoned the structural principle of design of

Figure 20
Hieroglyph with
the Parasol,
1917/96
Pencil drawing,
19.5 x 14 cm,
Felix Klee
Collection, Bern

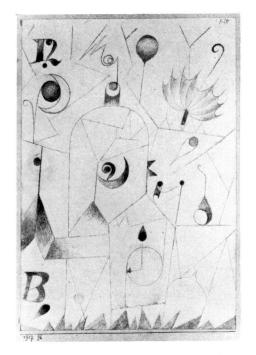

Klee's works from 1915 in favor of a loose
diffusion of symbols over the pictorial surface.
These symbols comprise notations or
psychograms, which, without forcing a
preconceived order upon the composition,
indirectly record whatever the irrational
impulse dictates. In Klee's words, the artist's
hand becomes totally "an obedient instrument
of a remote will."

The signs and symbols included in Klee's
works from this time on are ambiguous and
often cannot be reduced logically to a single
meaning. They arouse notions and concepts
which the artist, through a kind of second
creative act, circumscribed with a poetic
title—a title that serves as the key for solving

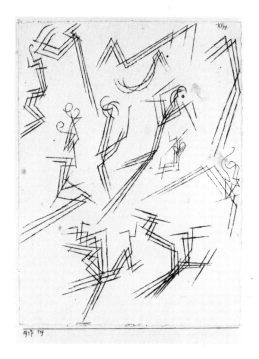

Figure 21
Embryonic
Abstract
Elements,
1917/119
Pen drawing,
19.5 x 14.5 cm,
Felix Klee
Collection, Bern

the picture puzzle. An eye from which a tear drops, a heart pierced by an arrow, sinking hills, and low-hanging blossoming branches whose leaves are severed by a razor, can all be understood as metaphors for pain and suffering. It is highly probable that Klee intended the watercolor *Flowers in Mourning* as a requiem for his friends Franz Marc and August Macke, who died in the war. "Art does not reproduce the visible but makes visible," is the claim formulated in Klee's 1919 "Creative Credo," which attained epoch-making significance as a guiding principle.

Around Christmas 1918, Klee left the military and returned to Munich.

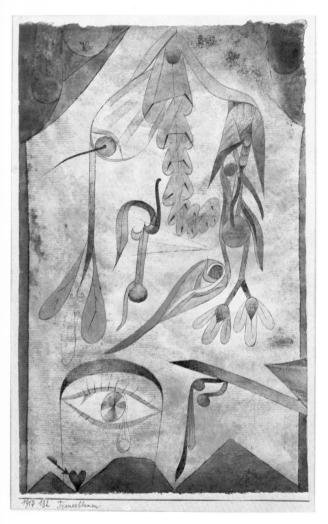

Figure 22
Flowers in
Mourning,
1917/132

Watercolor and pen,
22.9 x 14.4 cm,
Bayerische Staats-
gemälde Collections,
Munich (loan)

30

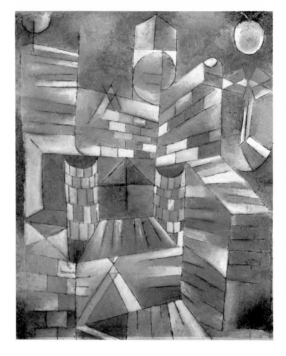

Until the age of forty, he had used the small
format of graphics, drawings, glass paintings,
and watercolors to practice his art—yet, with
few exceptions, he had done nothing in oil.
Klee now turned with great intensity to panel
paintings. The pigments in these works,
sometimes applied as paste, sometimes as
transparent glazes, display a deeply radiant
mellowness. White brushstrokes outline the
contours and determine the highlights. As if
enjoying a rediscovered domestic security,
Klee painted houses and gardens over which a
heavenly body kept watch: *Architecture with
Window, Red Villa District.* The pensive and

tranquil quality of these panels communicates
a contemplative, inward-directed disposition,
which the artist expressed in 1919 through his
self-portrait *Lost in Thought* and through the
statement, "I cannot be understood at all in
the here and now. For I live just as well with
the dead as with the unborn. Somewhat closer
to the heart of creation than usual—but far
from close enough."

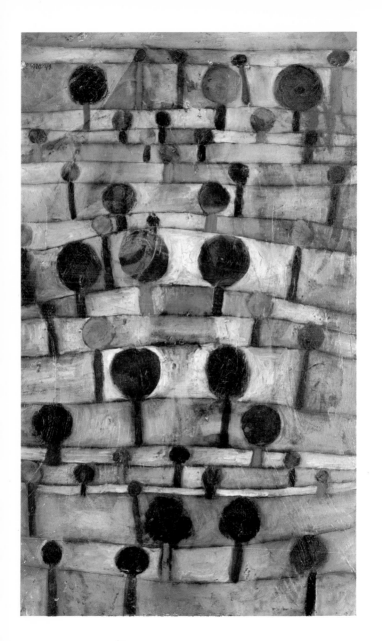

34

If in the paintings of facades and houses the planimetric and colored division of surfaces constituted the structural schema, Klee used a horizontal framework of lines to represent open landscape. In *Rhythmic Tree Landscape,* the rounded tree tops function like notes in a musical score, and the rhythmic repetition seems to expand the scenic area beyond the borders of the painting.

Figure 26
Rhythmic Tree
Landscape,
1920/41
Oil on cardboard,
47.5 x 29.5 cm,
Marlborough Fine
Art Ltd., London

Klee's postwar paintings can be regarded as the first masterpieces within his *oeuvre* and mark the beginning of his mature period. It was at this time that Klee met with outward success. His first theoretical essay appeared in the anthology "Creative Credo." Kurt Wolff published *Candide* with Klee's illustrations of 1912. Outstanding monographs by Leopold Zahn, H. Von Wedderkop, and Wilhelm Hausenstein appraised Klee's artistic achievements. Hans Goltz held a large retrospective that surveyed Klee's work up to that time in the spring of 1920. Finally, in October 1920, Walter Gropius invited Klee to join the faculty of the State Bauhaus in Weimar.

Bauhaus

Artistic training at the Bauhaus centered on handicraft. The schism between the fine and applied arts was to be surmounted, and all arts were to merge into a totality of accomplishment. Klee, who taught for ten years at the Bauhaus, served as master of design in a workshop, first in bookbinding, and later in glass painting. In addition, he gave lectures on design and composition. Klee's teaching work necessitated the development of a theoretical system and the refinement of suitable educational tools. In 1925, Klee's contributions to the theory of pictorial form appeared under the title *Pedagogical Sketchbook,* as part of the series of texts published by the Bauhaus.

Klee's appointment to the Bauhaus initiated a decade of decisive artistic development. While in Weimar, Klee entered into a circle of highly promising creative forces: at one time or another, the faculty of the Bauhaus consisted of such important artistic personalities as Lyonel Feininger, Johannes Itten, Oskar Schlemmer, Kandinsky, and Laszlo Moholy-Nagy. Productive influences resulted from the lively intellectual exchange between teachers and students.

The aim of artistic education at the Bauhaus was to enhance formal awareness, particularly as exemplified by architecture and its principles. Klee particularly stressed tectonic concepts in his teaching. He taught that the pictoral work is "built up piece by piece, the

Figure 27
Paul Klee,
Wiesbaden, 1924

same as a house." He taught that like the
engineer, the painter has the power of creating
things so strong" and the power of carefully
balancing out the formal elements until he
finally achieves an equilibrium. The analysis of
pictorial processes had a definite clarifying
effect on Klee's work. An examination of his
composition methods up to that time would
show that forms and figures were usually
intersected by the edge of the sheet or
painting. In fact, Klee often completed his
work, as he related in his diary from 1911,
"by applying the basic pseudo-Impressionist
principle: 'What I don't like, I cut away with
the scissors.'" The picture thus appears as a
fragment of a greater entity still to be realized.
Yet Klee now demonstrated a desire to design
the picture as an independent organism,
completed by the square of its frame. Klee
aspired to a pictorial totality and did not
strictly limit himself to its formal aspect. In

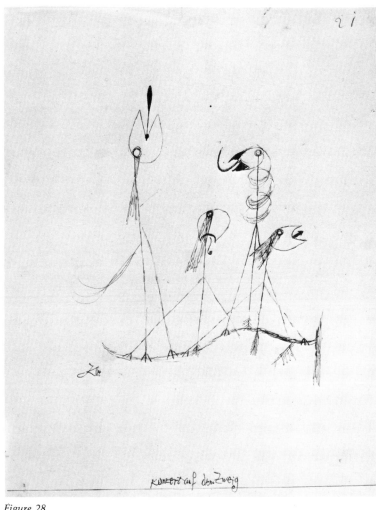

Konzert auf dem Zweig

Figure 28
Recital on the Branch, 1921/188 Pen drawing, 28.1 x 22.1 cm, Paul Klee Foundation, Bern

1924, he admitted in a lecture held on the occasion of an exhibit of his works in the Jena Art Society, that he dreamed of a "work of vast scope, spanning all the way across element, object, content, and style."

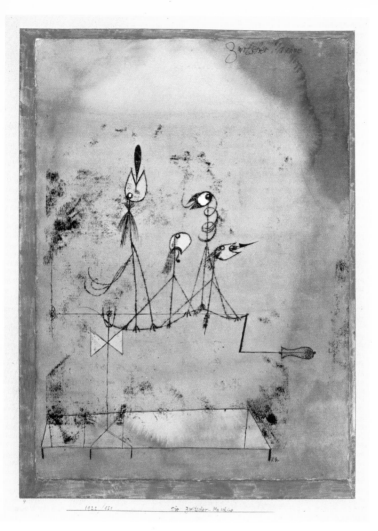

Figure 29
The Twittering
Machine,
1922/151

Watercolor and
oil drawing,
41.3 x 30.6 cm,
The Museum of
Modern Art,
New York

39

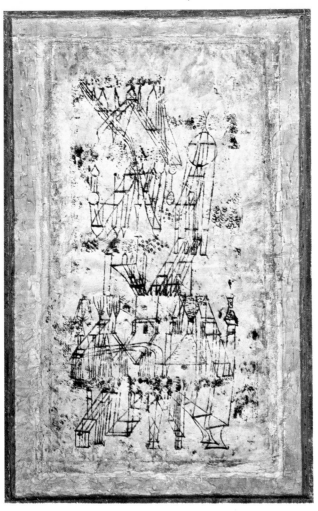

Figure 30
Lofty Castle,
1922/42
Watercolor and oil
drawing on gesso-
primed gauze,

61 x 39 cm,
Kunstmuseum, Bern,
Hermann and
Margrit Rupf
Collection

Figure 31
Drawing II
1922/42,
1922/41
Pen drawing,
29 x 22 cm,
Galerie Berggruen
& Cie, Paris

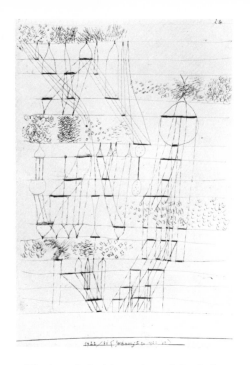

Figure 31
Drawing II
1922/42,
1922/41
Pen drawing,
29 x 22 cm,
Galerie Berggruen
& Cie, Paris

Klee's technical invention of the "oil
drawing" can be understood as an aid toward
realizing this goal. This method allows the
painter, using a middle sheet covered with
black oil paint, to transfer drawings by a
tracing process onto a new sheet and in this
way to determine anew the relationship
between figure and ground. The original
design can also be altered—as in the case of
the watercolor *The Twittering Machine,* which
is based on the pen drawing *Recital on the
Branch.* Or several motifs can be assembled
within a new composition: Klee used *Drawing
II 1922/42* for the upper half of the painting
Lofty Castle. In order to intensify the
impression of floating in airy heights, he

41

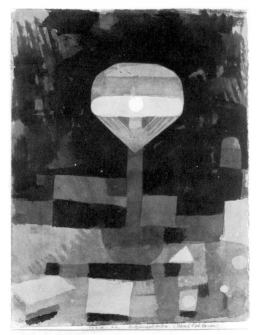

Figure 32
Desk Lamp
(Chiaroscuro Study),
1924/22
Black watercolor,
29 x 23 cm,
Galerie Berggruen
& Cie, Paris

placed the fragile structure within the open
pictorial surface and did away with the linear
system which, in the drawing, had linked the
imaginary edifice to the edges of the sheet.

Klee's theory of art derived from the basic
pictorial elements of line, *chiaroscuro,* and
color. The experience of his own development
and the theoretical notions jotted down in his
diaries could be systematized into a set of
doctrines for teaching purposes. He explained
the use of *chiaroscuro* through the
"measurement process" of his black
watercolors of 1908 and then illustrated the
procedure in the *chiaroscuro* studies *Desk
Lamp* and *Easel Lamp.*

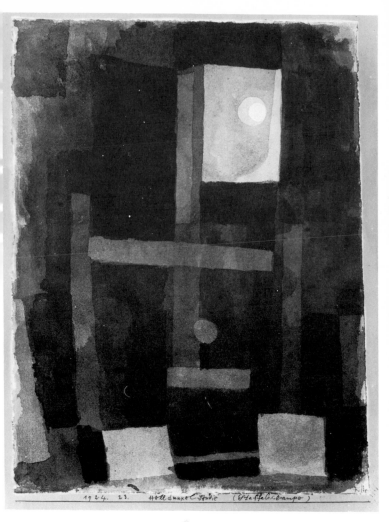

Figure 33
Easel Lamp
(Chiaroscuro Study),
1924/23
Black watercolor,

30.5 x 23.5 cm,
Kunstsammlung
Nordrhein-
Westfalen,
Düsseldorf

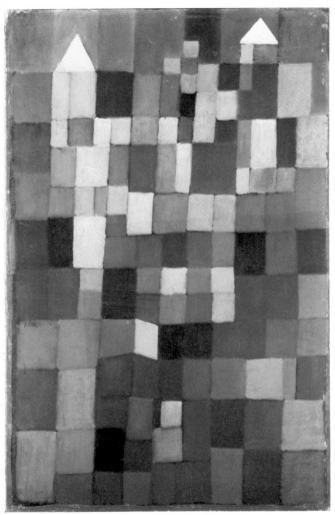

Figure 34
Architecture
(Yellow-Violet
Stepped Cubes)
1923/62

Oil on cardboard,
57 x 37.5 cm,
Nationalgalerie,
Berlin

44

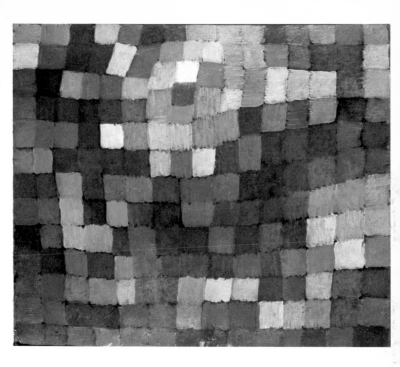

Figure 35
Abstract May
Picture,
1925/120
Oil on cardboard,
41.5 x 49.5 cm,
Galerie Berggruen
& Cie, Paris

Klee's elucidation of the laws and relationships of color, as demonstrated by the color wheel and color sphere, led to his paintings of colored squares. The rectangular division of surfaces, which had been associated with the structure of the landscape in his Tunisian watercolors was from this point on based on autonomous pictorial principles. Whereas two triangles, topping off rectangular shaped roofs, evoke a kind of *Architecture*, the true meaning of the painting lies in the two-tone harmony of the colors yellow and violet and in the rhythmic oscillation between these complements. With increasing fullness of tone, Klee orchestrated his paintings of

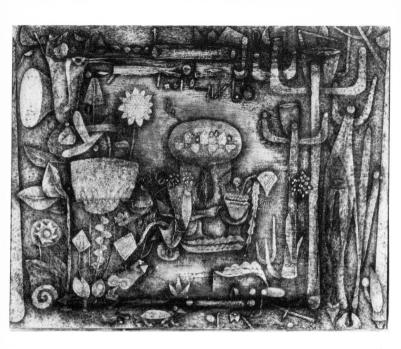

*Figure 36
Botanical
Theater,
1924–34/219
Oil and water-
color on card-
board, mounted
on plywood,
50.2 x 63.5 cm,
Städtische
Galerie, Munich*

squares to the "full-blooded colour harmony."
Abstract May Picture of 1925 includes all of
the colors of the spectrum and links them to
the gray values of the *chiaroscuro* scale,
mediating between black and white. Through
his masterful control of color, Klee fulfilled his
wish of 1910 to "some day be able to
improvise freely on the chromatic keyboard of
the rows of watercolor cups." In accordance
with Klee's assertion that "nature is creative,
and we are creative," then "for the artist,
dialogue with nature remains a *conditio sine
qua non.*" Klee did not view the imitation of
external phenomenona, the "completion of
form," to be the consequence of a creative

46

*Figures 37–39
Details from
Botanical
Theater,
1924–34*

nature. On the contrary, Klee believed that insight into natural growth processes, as expressed in his 1923 essay "Ways of Nature Study," allows the artist "to form free abstract-structures which surpass schematic intention and achieve a new naturalness, the naturalness of the work."

Animal existence and the phenomenon of botanical growth are the subjects of two paintings, that can be numbered among Klee's masterpieces: *Botanical Theater* and *The Goldfish*. In *Botanical Theater,* contours are drawn with a very fine brush and covered with a kind of fluctuating fur-like hatching, the varying density of which molds the shapes and

47

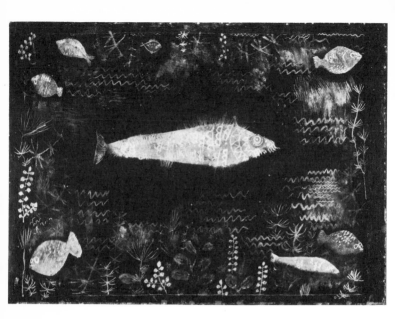

Figure 40
The Goldfish,
1925/86
Oil and water-
color on Ingres
paper, mounted
on cardboard,
48.5 x 68.5 cm,
Kunsthalle,
Hamburg

generates light and shadow. Stage area, scenery, and actors are embodied by vegetable elements. A wondrous growth, comprised of a symbiosis of plant and animal dominates the theatrical landscape. *Botanical Theater* might well depict the realm of archetypes and primary phenomena, the "primal ground of creation," as Klee explained in his Jena lecture, "where the primal law feeds the forces of development."

If in *Botanical Theater* rich tones of brown, green, and red transmit an earthly warmth, the pure three-tone harmony of the primary colors red, blue, and yellow creates the cool, clear element of *The Goldfish*. Frozen in transitory, energized motionlessness, the glistening magical fish illuminates the dark blue, shadowy world where the small red fish take refuge.

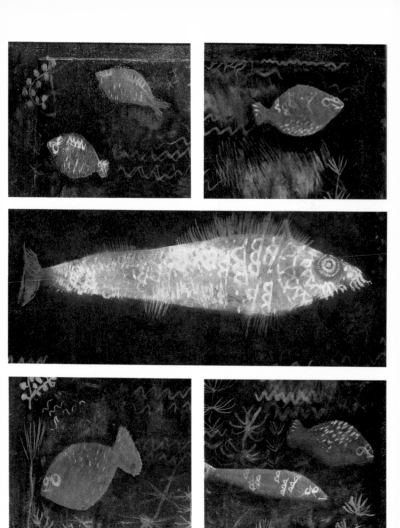

*Figures 41–45
Details from
The Goldfish,
1925*

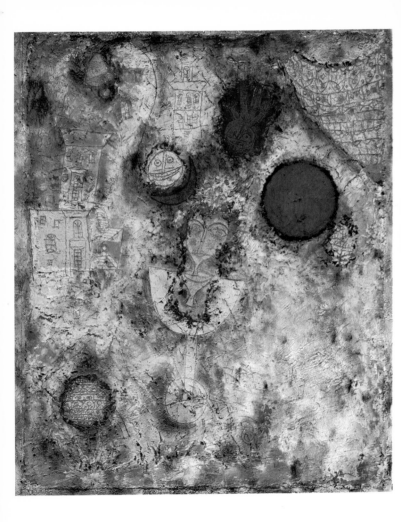

Experiments with unusual grounds and refined technical processes resulted in new artistic solutions, which occasionally let Klee venture into artistic areas that would be fully developed after World War II. In *Magic Garden,* the dull surface contrasts with patches of color out of which the artist conjured up figures and objects by scratching fibrous structures into the rough plaster ground. These so-called engravings vigorously act upon the observer's tactile and optical senses. Because of the astoundingly fantastic quality of such paintings, the Surrealists considered Klee a precursor of their movement and in 1925 urged him to participate in their first Paris exhibition, *Peinture surréaliste.*

The regularities of formative and structural energies as formulated in Klee's theory of composition were effectively utilized in several of his pictures. *A Garden for Orpheus* and *Scenic Rug* are masterpieces of drawing and watercolor technique. The summation, imitation, and polyphonic overlapping of individual elements—echelons of parallel lines that often crisscross each other in the pen drawing, dense rows of angular colored particles in the watercolor—create an evenly textured cellular unit of intangible transparency. In the fall of 1926 Klee traveled through Italy and visited Ravenna, and the question arises whether the Ravenna mosaics inspired him to design the richly colored pointillist pattern of the *Scenic Rug.*

The Bauhaus moved to Dessau in 1925. Discussion there centered on the artist's role in industry and technology, which limited instruction to what was purely rational in nature.

Figure 47
A Garden
for Orpheus,
1926/3

Pen drawing,
tinted yellow,
46.8 x 32.1 cm,
Paul Klee
Foundation, Bern

Figure 48
Scenic Rug,
1926/149

Watercolor,
37 x 23 cm,
Private
collection,
Switzerland

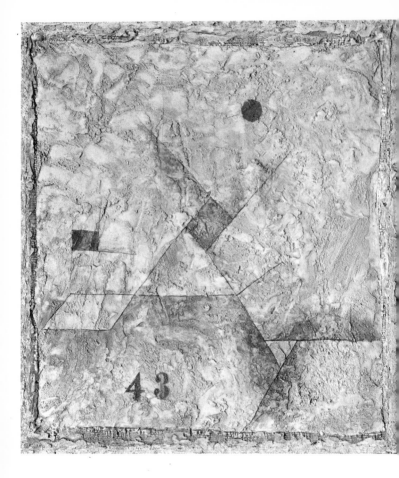

Figure 49
"43," 1928/145
Watercolor on
plaster panel,
36 x 32.5 cm,
Kunstsammlung
Nordrhein-
Westfalen,
Düsseldorf

In Klee's work as well, geometric and structural principles of design acquired increasing significance. Klee worked more and more frequently with technical tools such as T-squares, protractors, and compasses, and deliberately abandoned the subjectively determined paintbrush. In *Artist's Portrait* and *43*, the mathematical language of the pictures

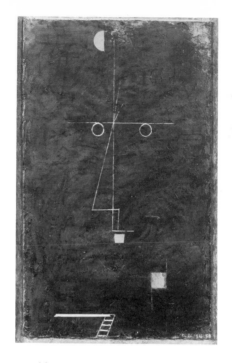

Figure 50
Artist's Portrait,
1927/13
Oil on cardboard,
62.9 x 40.6 cm,
The Museum
of Modern Art,
New York

provides a delightful contrast to the somber, roughly textured grounds. A comparison of *Artist's Portrait* with *Actor's Mask* (Figure 2) or of *Conjuring Trick* (Figure 51) with *Magic Garden* (Figure 46) lets the observer follow Klee's progressive simplification of forms. Yet despite his use of mathematical and abstract modes of expression, the content of the picture remained an essential element as far as Klee was concerned.

In his programmatic essay "Exact Experiments in the Realm of Art" (1928), Klee warned of the erroneous assumption that the constructive impulse can totally replace artistic intuition: "We document, explain,

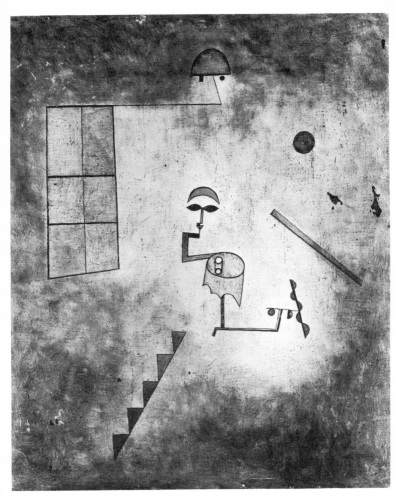

*Figure 51
Conjuring Trick,
1927/297
Oil and watercolor
on cardboard,
49.5 x 42.2 cm,*

*Philadelphia
Museum of Art,
Louise and
Walter Arensberg
Collection*

justify, construct, organize: these are good things, but we do not succeed in coming to the whole." The work does not equal the law, "it is above the law," and, according to Klee's essay on "Graphics" of 1918, without intuition, the artist is incapable of producing "art in the highest circle, where the secretive begins and where the intellect lamentably expires."

Klee's work from his last Bauhaus years is notable for its masterly execution. The wealth of his formal inventions is inexhaustable, and new thematic dimensions are opened up. His more conscious use and total appropriation of the "cultivation of the pictorial elements" allowed Klee to realize "an association between philosophy and pure craftsmanship," in keeping with his 1917 maxim, "The formal has to fuse with the *Weltanschauung.*"

In *Limits of the Intellect,* the distance between the earthly and cosmic realms is graphically depicted through the contrast between the static, multipartite, and jagged linear construction and the free-floating disk. In the *Pedagogical Sketchbook,* Klee explained the genesis of the circular body in the following fashion: "The purest form of movement, i.e., the cosmic, arises solely through the removal of gravity (by breaking the bond with the earth)." As the thematically related pencil drawing *Crescent Moon above Rationality* indicates, the web of upward-rising parallel lines illustrates the principle of rationality. In the case of *Limits of the Intellect,* the lines are crystallized into a human physiognomy. Swaying ladders, seeking to reach the celestial body, symbolize the human endeavor, "after overcoming painful earthly

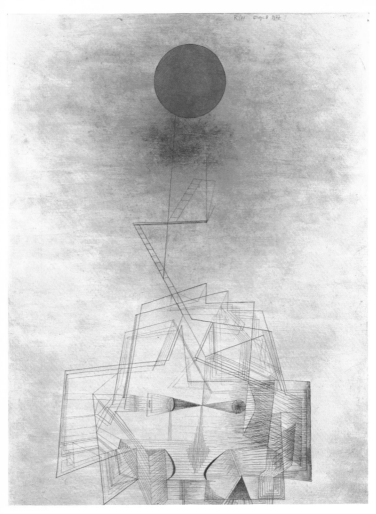

Figure 52
Limits of
the Intellect,
1927/298
Oil and water-
color on canvas,

56.3 x 41.5 cm,
Bayerische
Staatsgemälde
Collections,
Munich

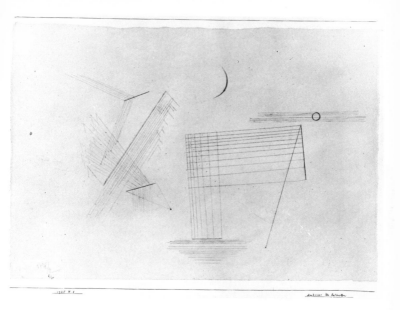

Figure 53
Crescent
Moon above
Rationality,
1925/235
Pencil
drawing,
30.5 x 46 cm,
Galerie
Renée Ziegler,
Zurich

constraints, to attain salvation in the universe, in silent, pure, matter-of-fact dynamism."

The black *Arrow in the Garden* points to a kind of cathedral architecture to which staircases and flower-strewn paths lead in a diagonal movement. Beyond the portal, steps and ladders invite one to climb up to the magnificent celestial body. Like the cliff entrance in *A Garden for Orpheus,* above which rises the Christian cross, the gate in this picture functions as a symbol of death. The garden, on the other hand, is a life motif. The arrow is not merely an abstract sign, but signals a specific meaning and, as a mental guidepost, mediates between "constraint" and "release." For according to the *Pedagogical Sketchbook,* "the father of the arrow was this thought: how shall I increase my reach in that direction?"

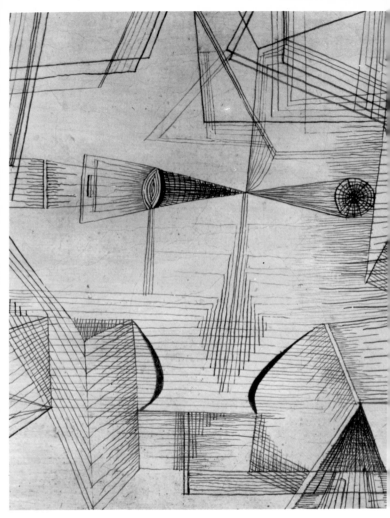

Figure 54
Detail from
Limits of
the Intellect,
1927

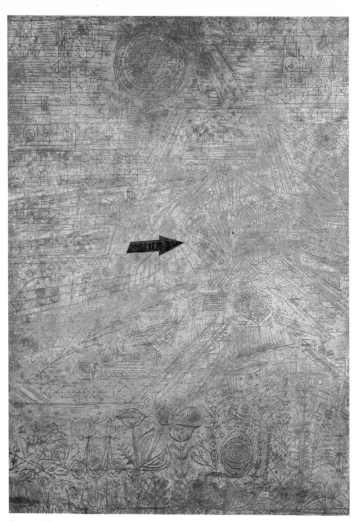

Figure 55
Arrow in the
Garden, 1929/97
Tempera and oil on
canvas, 70 x 50 cm,
Private collection, Paris

After 1930, Klee dealt with structural problems of equilibrium and the phenomenon of weightlessness in an extensive series of geometric drawings. Drafted with a pen, straight edge, and compass, and executed in black or colored ink, the planimetric and stereometric constructions in these works always derive from a basic design which Klee termed a "model" and to which he assigned a number. Whenever such "models" are included in Klee's paintings, they serve as symbols of balance and free suspension.

Model 7a in Altered Positions and Formats becomes a sailboat in *Possibilities at Sea.* Different laws of stasis rule the water than those that rule the land. The weightless disposition of fish had been the subject of the magical painting *The Goldfish* in 1925. A balanced movement, inconceivable on land and possible only at sea, is exemplified by *Possibilities at Sea* as well. The gravity of the atmosphere, indicated by the black arrow, is countered by the buoyancy of the water. The opposed forces cancel each other out and allow the ship construction to follow its own course, i.e., that of the white arrow.

Geometric configurations embody the most crucial realization of Klee's theoretical notions. They represent a culmination as well as a conclusion: Klee's interest in theory and system seemed to have finally exhausted itself once he found a solution.

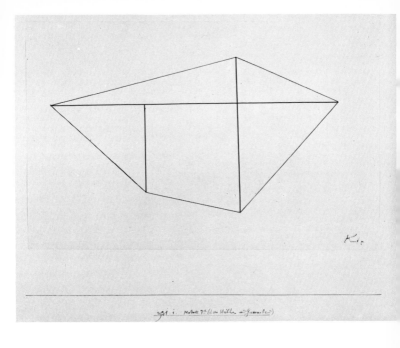

Figure 56
Model 7a (three
small rods and
an elastic band),
1931/1
Drawing pen,
20.9 x 33 cm,
Paul Klee
Foundation, Bern

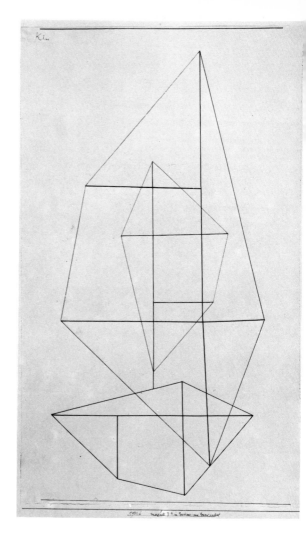

*Figure 57
Model 7a in
Altered
Positions
and Formats,
1931/6
Drawing pen,
60.3 x 37.3 cm,
Paul Klee
Foundation,
Bern*

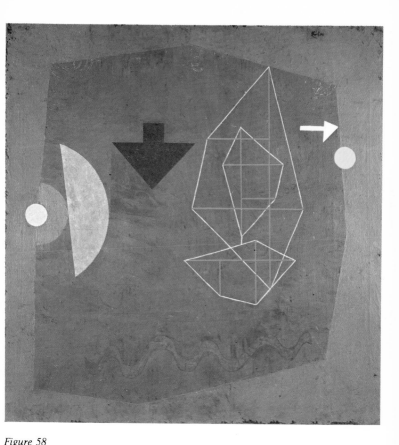

Figure 58
Possibilities
at Sea, 1932/26
Oil on canvas,
97 x 95 cm,
Norton Simon
Museum, Pasadena.
Blue Four, Galka
E. Scheyer
Collection

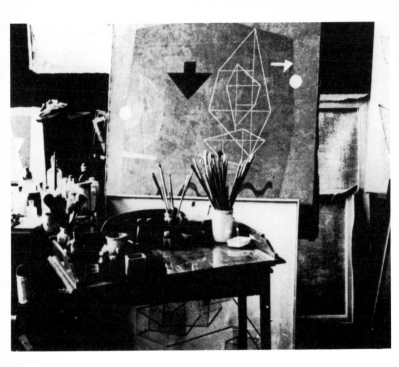

Figure 59
Paul Klee's
Studio,
Dessau, 1932

The Bauhaus painters had to defend themselves more and more strongly against the general tendency toward functionalism, which considered the visual arts to be totally superfluous. The institute, moreover, had fallen into the fatal whirlpool of political and social unrest and became afflicted with serious differences of opinion. Teaching there eventually became a burden. On April 1, 1931, Klee assumed a professorial chair at the Düsseldorf Art Academy, which promised easier instruction and fewer conflicts.

Düsseldorf

The central artistic concern of Klee's Düsseldorf period was the matter of light—namely, pure light, radiating from the free use of various colors. The representation of light in Klee's works up to this time had been linked to the *chiaroscuro* polarity, to the contrast of white and black, as Klee's *Chiaroscuro Studies* clearly illustrate. After 1930 Klee adopted a technique that he labeled "divisionism"; the beginnings of this technique can be seen in the watercolor *Scenic Rug* of 1926 (in which Klee, of course, was still using black paint). A cloudy layer of paint or a sectioned-off ground is covered with a system of regularly spaced dots of color. When viewed together, the ground and color particles permeate one another to produce an organism of great depth, and generate in the spectator's eye the illusion of colored light, devoid of shadows.

In *Rising Star,* the pointillist technique leaves space for geometric figures and suspended horizontal bars that convey the weightlessness of light. The shimmering blue evening star leaves behind the jagged trace of its ascending movement in the oscillating atmosphere. Klee's evolution into a

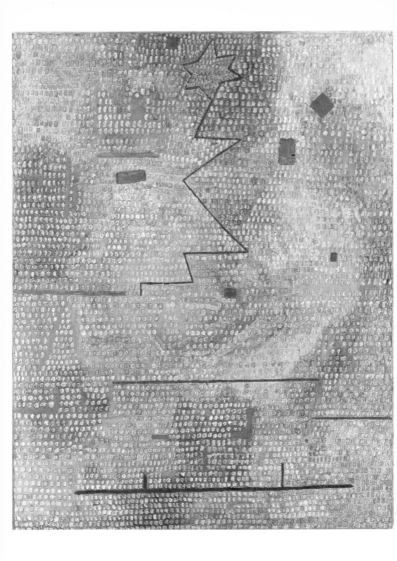

Figure 60
Rising Star,
1931/230
Oil on canvas,
63 x 50 cm,
Galerie
Beyeler, Basel

monumental and lapidary style, initiated at the outset of the thirties, required new kinds of grounds, that is, dry, rough fabric such as jute or burlap. In *Hat, Lady, and Small Table,* the transparent watercolor exposes the rough structure of the burlap canvas. With increasing frequency, Klee curbed the intellectual direction of the picture and gave free reign to his drawing hand. An intricate and playful linear design outlines surface formations that polyphonously overlap one another. As if by its own power, a human silhouette emerges, and Klee needed only to complete the physiognomy with a pair of eyes and a heart-shaped mouth. This intuitive method of working marks a shift toward the irrational and the metaphysical, which characterized Klee's final creative phase.

The question of "how much happiness can lie within a few lines"—raised by Klee in a letter dated January 31, 1933—might well constitute the theme of the subsequent group of works. A "triad" of three linear strokes divides the sheet into eight broad fields in the work *Hot Place,* which lies, as its subtitle specifies, "Between Cross, Circle, and Triangle" and signifies the birthplace of an angel. Placed on its narrow right side, this composition served Klee in 1934 as the model for the panel painting *Angel in the Works.* If the wax crayons Klee used in *Hot Place* permitted the exposure of the English red paper ground, the "blade technique" of the oil painting *Angel in the Works* produced a thick, pasty mural of substantial presence. The theme

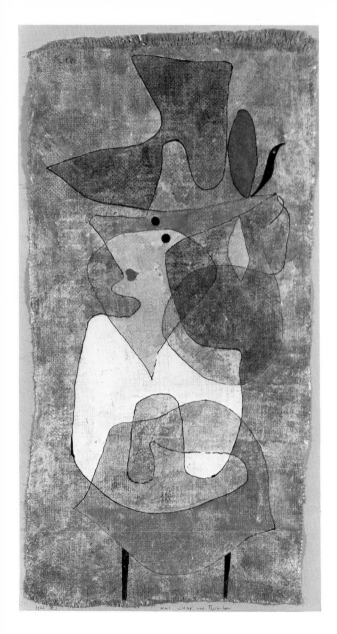

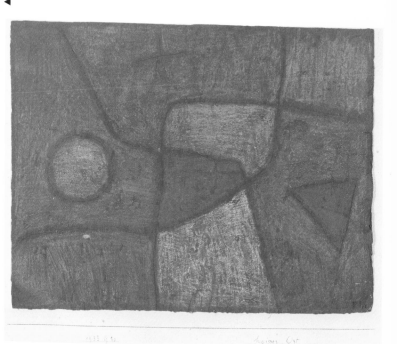

Figure 62 Wax crayons,
Hot Place 23 x 31.5 cm,
(Between Cross, Karl Ströher
Circle, and Collection,
Triangle), 1933/440 Darmstadt

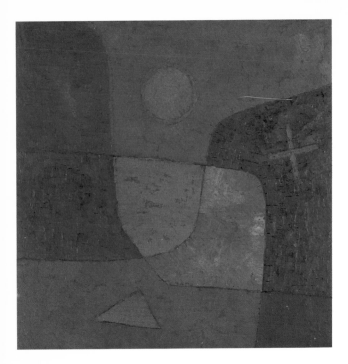

Figure 63
Angel in
the Works,
1934/204
Oil on
plywood,
51 x 51 cm,
Felix Klee
Collection,
Bern

of the picture hinges upon the symbolic cross.
Angel in the Works can also be understood as
a *Diagram of Salvation,* the title of an
ideogram-like drawing that appeared at the
same time.

Hitler came to power at the end of January
1933. The Nazi storm troopers searched Klee's
house in March and temporarily confiscated
his correspondence. In April, he was suddenly
released from his position at the Art
Academy. Shortly before Christmas he left
Germany and returned to Bern. In 1935 an
exhibit of 273 works from Klee's own
inventory was held in the Bern Kunsthalle. It
was for this occasion that the painter

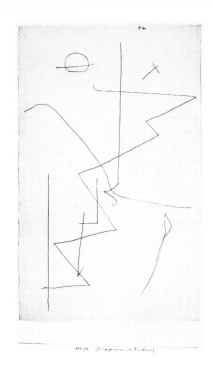

completed *Botanical Theater* after a ten-year
interruption, and transformed several older
colored sheets into paintings, among them
Angel in the Works and *Lady Daemon*, a new
version of *Hat, Lady, and Small Table* in a
larger format.

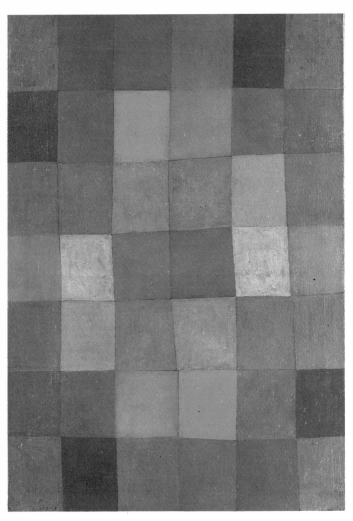

Figure 65
New Harmony,
1936/24

Oil on canvas,
93 x 66 cm,
The Solomon
R. Guggenheim
Museum, New York

Klee's Final Works

In the summer of 1935, the first signs of Klee's fatal illness became noticeable. In the following year, after another outbreak, it was diagnosed as sclerodermia. Klee's artistic production dropped to 25 works (oil paintings, watercolors, and drawings) in 1936—the lowest level in his career. Among the five paintings Klee produced in 1936 is his last—as well as his largest, with dimensions of 93 by 66 cm —picture of squares: *New Harmony*. To be sure in the following years Klee continued to produce compositions of rectangular fields, yet he always linked them to pictorial signs, as *Severing of the Snake* of 1938 emphatically indicates.

Figure 66
Reflection, from
Special Order
(60/68)
Paul Klee
Foundation, Bern

Figure 67
Paul Klee,
Bern, 1938

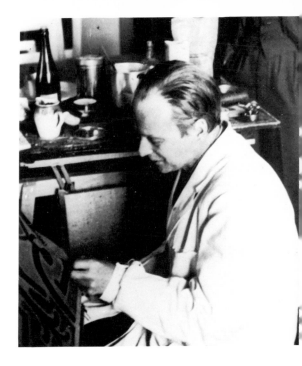

New Harmony radiates a clarity and
tranquility that are ascribable not only to the
complementary pair of red and green colors
and their equalization as gray, but also to the
schematic arrangement of colors in accordance
with the Bauhaus theory, which Klee had
never consistently followed until this time. The
central vertical line also functions as a
mirror-axis, at which point both halves of the
painting are reflected; if the viewer starts at
the center and moves outward, he sees that
each half row has a reciprocal half across from it.

Klee's artistic production took a powerful
upswing in 1937 and did not let up during his
remaining creative years. His life and art were

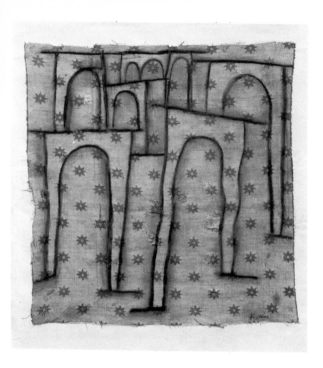

*Figure 68
Viaducts Break
Ranks, 1937/111
Charcoal and
ocher on a
tablecloth,
42.6 x 41.6 cm,
The Solomon
R. Guggenheim
Museum,
New York*

molded into a unity more tightly than ever
before. "If the joy of living meets with many
an impediment today, can one perhaps
reconstruct it by means of the roundabout
path of work?" Klee pondered in November
1939. "Since work can have good periods, a
kind of contentment sometimes ensues." The
small living room that had to serve him as a
studio could not hinder the increasing size of
Klee's paintings. The effort it cost him to
overcome such obstacles may be detected in a
photograph that shows Klee at work on
Intention (75 by 112 cm): in order to paint the
upper left corner, he had to turn the painting
on its head. *Insula Dulcamara*, with

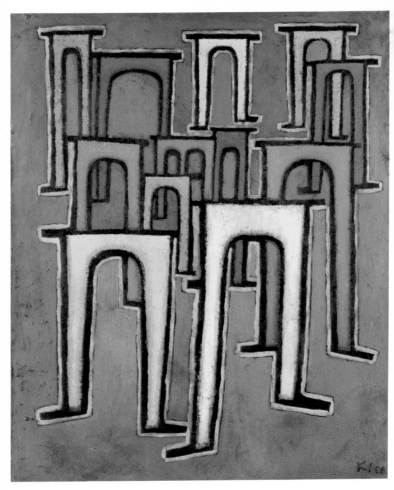

Figure 69
Revolution of
the Viaduct,
1937/153
Oil on cotton,
60 x 50 cm,
Kunsthalle, Hamburg

dimensions of 88 by 176 cm, is the largest
work in Klee's *oeuvre*.

Even at this late stage, Klee prepared for
his major creations with drawings and colored
sheets. *Viaducts Break Ranks,* drawn in
charcoal and ocher on a worn red tablecloth

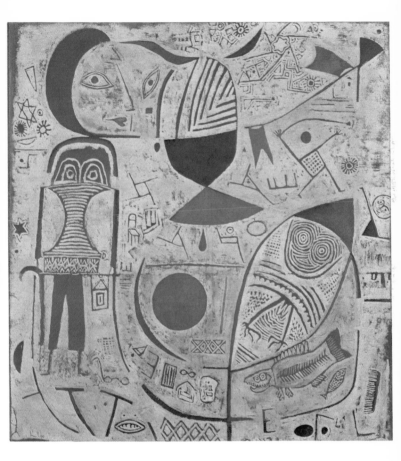

*Figure 70
Sheet of
Pictures,
1937/133*

*Oil on canvas,
59 x 56 cm,
The Phillips
Collection,
Washington*

79

with a woven star pattern, immediately
precedes Klee's central work of 1937,
Revolution of the Viaduct. The arcades have
rid themselves of their common yoke and
ominously march as individuals toward the
spectator; they suggest a decline in order, of
which the artist became aware as he grew
increasingly ill and when the reactionary Nazi
Party repudiated his art as "degenerate." In
addition to reflecting Klee's own fate,
Revolution of the Viaduct is a clear-sighted
symbol of contemporary events—a modern
example of history painting.

Recalling Klee's drawings of 1917, the
hieroglyphs in the puzzling *Sheet of Pictures,*

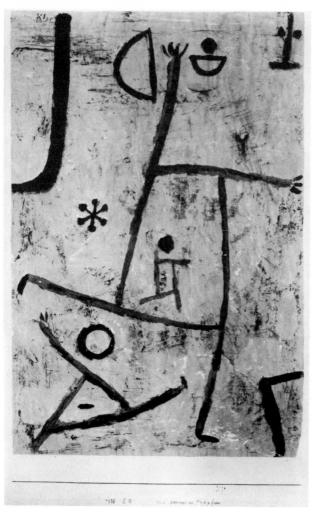

Figure 73
With Special
Heads,
1938/50
Glue-based pigments,

48.5 x 33 cm,
Museum
Boymans-van
Beuningen,
Rotterdam

Figure 74
Alphabet I,
1938/187

Black paste
watercolors,
53.9 x 34.5 cm,
Paul Klee
Foundation, Bern

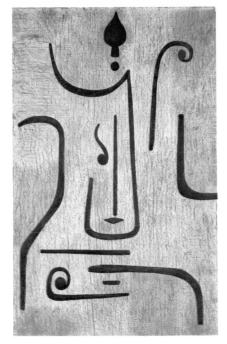

Figure 75
Archangel,
1938/82
Oil on cotton,
mounted on
burlap,
100 x 65 cm,
Städtische Galerie,
Munich

composed of emblematic and abstract signs, offer plenty of room for the viewer's imagination. In Klee's works from this period the human figure is sometimes reduced to a rhythmic formula, as is present in abstract form in the painting *43*: triangles, squares, and trapezoids with elongated sides evolve into figures in *With Special Heads*.

With Special Heads is painted on newspaper with glue-based pigments, a process Klee also employed in the paintings *Intention* and *Insula Dulcamara*. Gluepaint has a dry, rough quality, yet this material effect, reminiscent of a relief, is countered by a thin application of pigment that allows the newsprint to show through faintly. The sheet entitled *Alphabet I*,

Figure 76
Intention,
1938/126
Glue-based
paint on news-
paper, mounted
on burlap,

75 x 112 cm,
Paul Klee
Foundation, Bern

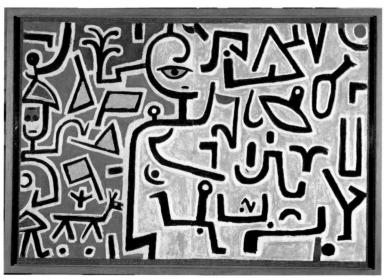

from a series of preliminary sketches for Klee's large hieroglyphic panels, provides information concerning Klee's working procedures and composition techniques. The signs were first drawn on the newspaper, and only then was the surface covered. The elements are not centered, but loosely scattered over the ground. During the course of the year 1938, Klee's brush strokes evolved into thick beams. From a few masterfully balanced lines arise monumental configurations, which achieve the expansiveness characteristic of a mural in *Archangel* and *Insula Dulcamara*.

Figure 77
Make Visible,
1926/66
Pen drawing,
11 x 30 cm,
Felix Klee
Collection, Bern

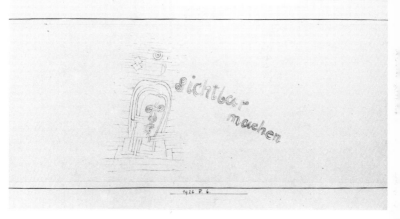

In *Intention,* the two parts of the picture are separated by the outline of a human figure closed on the left side. The cramped signs in the left third of the painting are solidified into representational motifs such as man, animal, plant, and flag. In contrast, the ciphers on the right side create an incoherent and fragmentary effect. Nonetheless, the complementary color contrast olive green and vermilion indicates that the pictorial fields correspond to one another. In 1926 Klee's inability to communicate through a drawing of a tilted head the workings of spiritual-intellectual powers had motivated him to issue

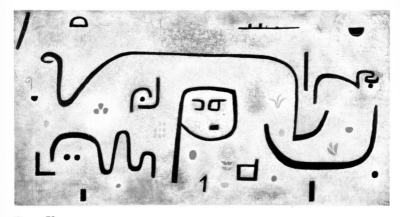

Figure 78
Insula
Dulcamara,
1938/481
Oil on news-
paper, mounted
on burlap,
88 x 176 cm,
Paul Klee
Foundation, Bern

a verbal warning "Make Visible." His invention of a sign language from that time on permitted the visualization of invisible and intangible processes. In *Intention*, a complex mental event acquires a form that incorporates a still inarticulate thought process as well as a future-oriented vision of intention.

Klee's sign imagery culminates in the unique symbolic work entitled *Insula Dulcamara*. Below the burdensome weight of the black beam-like lines flourish radiant colors that generate an atmosphere of ethereal transparency. Like the contrary Latin terms "dulcis" (sweet) and "armarus" (bitter) united in the title into a single word, the painting

Figure 79
Details from
nsula
Dulcamara, 1938

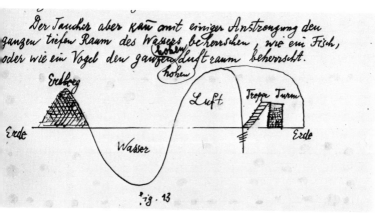

Figure 80
Earth, Water, and
Air, from
Contributions
to the Theory
of Design,
Paul Klee
Foundation, Bern

follows the principle of polarity, the basis of
Klee's theory of design and general
philosophy: "There is no such thing as a
concept in itself; generally speaking, there are
only pairs of concepts. What does 'above'
mean if there is no 'below'? What does 'left'
mean if there is no 'right'? What does 'behind'
mean if there is no 'in front'?"

The reciprocal semicircles at the top of this
picture can be interpreted in terms of Klee's
theory of form. The black-filled semicircle
hanging heavily downward represents water,
the upward turned empty semicircle represents
air. Along an imaginary horizon, i.e. the
diameter of the semicircles, a steamship

87

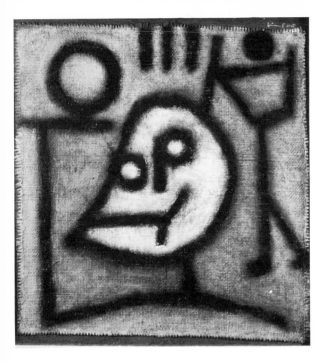

Figure 81
Death and Fire,
1940/332
Oil on burlap,
46 x 44 cm,
Paul Klee
Foundation, Bern

travels. A comparison of the face in this
picture with the chalk-white mask in Klee's
1940 painting *Death and Fire* clearly shows
that death rules over *Insula Dulcamara* as
well. Two contrary pairs of symbols represent
the transformation of life into death, of
finitude into infinity. The small rectangle with
the upward elongated right side embodies the
static principle of death; its rounded and
fertilized counter-image, lying diagonally to the
left of the head, embodies the dynamic
principle of life. The unit of measurement at
the bottom of the picture marked with a figure
1 symbolizes man's single span of life. On the
other hand, the line distended with an

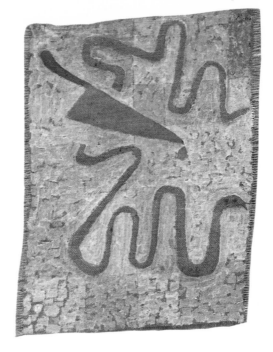

enormous breath of air hovering over the bottom half of the painting can easily be recognized as a snake, an ancient symbol of time and eternity. When severed by a powerful blow, as in *Severing of the Snake,* it once again becomes a death symbol. *Insula Dulcamara* depicts death within a universal, verdant landscape, within the cycle of nature, between earthbound existence and immortality; it represents a *memento mori* that may touch one person sweetly and fill another with bitterness.

In *Death and Fire,* the proximity of personal death has become inescapable. Klee revealed to his friend Will Grohmann on January 2,

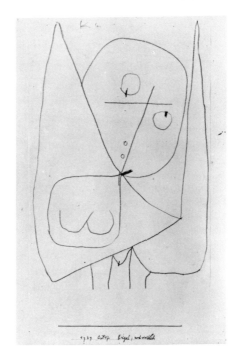

1940, "Of course, I do not accidently come
upon a tragic path; any of my works point to
it and announce that the time has come."

In addition to these pictures of death,
during his last creative months Klee executed
an extensive series of variations on the theme
of the "Angel." Independent of will and
intention, the expansive lines in these works
join together into strange winged beings: not
supernatural messengers from the beyond, but
Angel Candidates (as one title reads), members
of an intermediary kingdom still encumbered
with human imperfections and weaknesses.
Klee intended several of these drawings,
usually executed in rough pencil—such as

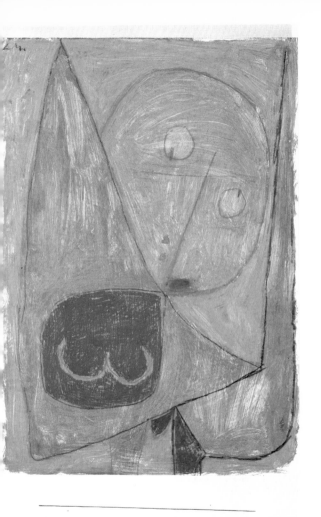

l:39 CD 16 Engel, noch weiblich

Figure 84
Angel, Still
Female,
1939/1016

Colored crayons,
41.6 x 29.5 cm,
Paul Klee
Foundation, Bern

91

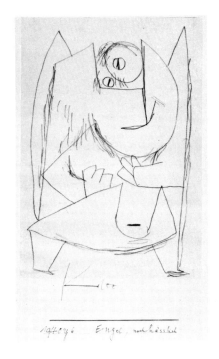

Angel, Still Female—for further coloring in
crayon or watercolor. However, the drawing
Angel, Still Ugly was incorporated, with the
addition of a redemptive cross, into the
untitled composition that has become known
as Klee's *Last Still Life*. This work was left
standing on the easel when Klee left his studio
on May 10, 1940 to convalesce in Tessin. As
Klee had most likely sensed he would, he died
on June 29 in Muralto-Locarno. Even though
it is not listed in the catalog of his works, the
Last Still Life must have been completed
toward the end of 1939 at the latest. The artist
had chosen this painting as the background for
photographs taken in December 1939 on the

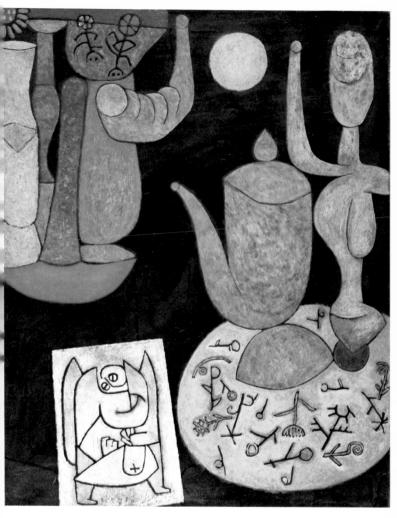

Figure 86
Untitled (Last
Still Life), 1939
Oil on canvas,

100 x 80.5 cm,
Felix Klee
Collection, Bern

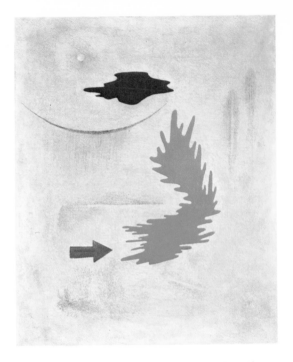

Figure 87
Mixed Weather,
1929/343
Oil and water-
color on muslin,
49 x 41 cm,
Felix Klee
Collection, Bern

occasion of his sixtieth birthday. Klee himself must have perceived this work as his artistic legacy.

Stylistically, the *Last Still Life* differs significantly from the flat drawings immediately preceding it. The painting is representational, and the objects possess a corporeality characteristic of several other works that appeared at the same time. The composition suggests a circular movement, the direction of which is indicated by the angel energetically striding toward the right. The impulse is directed diagonally inward toward the orange oval, then rises in a sudden upswing toward the bulging coffee pot and

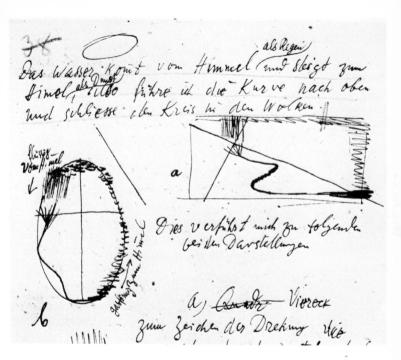

springs from the arm of the statuette pointing upward to the moon. The descent follows along the protruding, bulbous structure, and glides by the vases and balustrade column to return again to its starting point. "To connect beginning and end of a finite temporal process is to create a cycle," Klee taught in his second Bauhaus course, in which he clarified this motif, also present in the 1929 painting *Mixed Weather,* by means of a schema of meteorological circulation: "The water comes from the sky in the form of rain and rises up to the sky in the form of vapour. Thus I guide my curve upwards and complete the circle in the clouds."

According to Klee, the choice of perspective determines the nature of the circulation as microscopic or macroscopic: "The greater the rise of the vantage point chosen, the higher and farther away is the viewing eye, and the smaller must the units ultimately appear, even though closer up they still looked quite important, vesting the articulations in point with a wholly individual aspect."

Klee realized his concept of circulation, embracing earth and universe, particularly in the genre of the still life. The apparent contradiction within such an assertion disappears in light of a statement that Klee recorded in his diary in 1916: "The earth-idea gives way to the world-idea. I place myself at a remote starting point of creation, whence I state *a priori* formulas for men, beasts, plants, stones, and the elements, and for all the whirling forces."

In the still life *Around the Fish* (1926), the fish on the platter is surrounded by signs and emblems symbolic of growth and death in nature. The constellation of the cross and celestial body needs no further explanation: it is already familiar from the drawing *Diagram of Salvation*. In this connection, the fish can be viewed in terms of Christian symbolism as the sign of Christ, son of God, and Savior of the world.

In the so-called *Last Still Life,* the center of the painting remains empty, and the objects have been pushed back to the borders. The fact that the frame intersects the figures in many places bears out what Klee said at the conclusion of his remarks on the circulation motif: "In the course of time, wide areas have opened up on both sides to man's grasp and perception; but man has been unable to

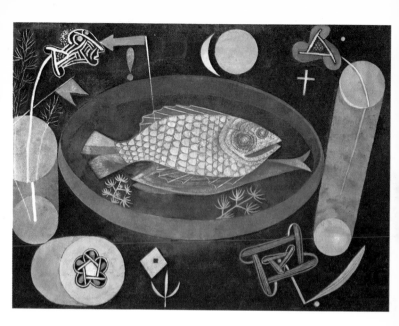

Figure 89
Around
the Fish,
1926/124
Oil-glazes on
muslin, mounted
on cardboard,
47 x 64 cm,
The Museum of
Modern Art,
New York.
Abby Aldrich
Rockefeller
Fund

transcend certain limits and will never be able to do so."

The *Last Still Life* is not only a metaphysical symbol of unending circulation within the universe, but also a metaphor for world evolution. Klee considered universal creation and artistic activity to be analogous: "Movement is inherent in all becoming, and before the work is, it must become, just as the world became before it was, after the words, 'In the beginning God created.'" The idea of the beginning of the world corresponds to the primal element of design, the point, which evolves into the line: "The first act of movement takes us far beyond the dead point." As a drawing, the picture of the angel in the *Last Still Life* illustrates the genesis of

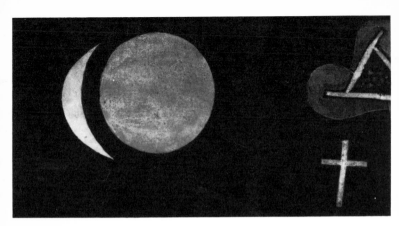

Figure 90
Details from
Around the Fish,
1926

the line before the viewer's eyes. Light and
darkness were never separate while in chaos.
The bright smaller picture of the angel
contrasts with the everpresent velvety darkness
of the ground in the surrounding painting. As
a young artist, it will be recalled, Klee had
greeted his discovery of *chiaroscuro* with the
exclamation "Let there be light!" According to
Klee, the poles of black and white indicate the
"distance from the very source of visibility to
the last limit of the barely visible." The light
causes the colors, which would otherwise be
submerged in darkness, to become visible, i.e.,
the complete purity of the "canon of colour
totality." From the basic pictorial elements of
line, *chiaroscuro,* and color, the composition
emerges as a formal cosmos. "The relation of
art to creation is symbolic. Art is an example,
just as the earthly is an example of the
cosmic."

Appendix

Chronology

1879	December 18, born in Münchenbuchsee near Bern.
1880	Parents move to Bern.
1886-1898	Attends grade school and secondary school in Bern until graduation.
1898-1901	Studies painting in Munich under Heinrich Knirr and at the Academy of Fine Arts under Franz von Stuck.
1900	Friendship with the pianist Lily Stumpf, born in 1876 in Munich.
1901-1902	First trip to Italy with the painter and sculptor Hermann Haller.
1902-1906	At parents' house in Bern.
1905	First trip to Paris with his friends Louis Moilliet and Hans Bloesch.
1906	September 15, marries Lily Stumpf after six-year engagement. Moves to Munich.
1907	November 30, birth of son Felix Paul.
1911	Meets Kandinsky and Franz Marc.
1912	Participates with seventeen works in the second "Blue Rider" exhibit at the Hans Goltz Gallery in Munich. Second trip to Paris.
1914	April 5-22, trip to Tunis and Kairouan with friends Louis Moilliet and August Macke.

1916	March 10, Klee is drafted into the German army. Infantry training in Landshut on Isar. Summer, ordered to pilot's school in Schleissheim, near Munich.
1917	Transferred to Bavarian Pilots' School in Gersthofen, near Augsburg. Two trips to the front to supervise the transport of aircraft. After supervising the transports, Klee worked in paymaster's office.
1918	Before Christmas, returns as a civilian to Munich.
1920	362 works exhibited at the Hans Goltz Gallery in Munich. Summer, at Possenhofen on Lake Starnberg. October, appointed to State Bauhaus in Weimar.
1921	January, begins teaching in Weimar. Summer, at Possenhofen on Lake Starnberg. October, moves to Weimar.
1922	Summer, in Possenhofen on Lake Starnberg.
1923	Fall, visit to the island of Baltrum.
1924	January 26, lecture in Jena Kunstverein. Founding of the "Blue Four" with Klee, Kandinsky, Feininger, and Jawlensky, under the auspices of Emmy Galka Scheyer. First exhibition in the United States. Summer trip to Sicily. December 26, Bauhaus closes in Weimar.
1925	The city of Dessau (in the district of Anhalt) takes over the Bauhaus. Participates in the first group exhibition of the Surrealists in Paris.
1926	August 1, moves to Dessau. Fall, trip to Italy via Bern; visits Genoa, Pisa, Elba, Florence, Bologna, Ravenna, and Milan.
1927	Summer trip to Hyères (via Bern), to Porquerolles and Corsica.
1928	Summer trip to Brittany. December 17 - January 17, 1929, trip to Egypt.

1929	One-man show of 150 works at the Flechtheim Gallery in Berlin. Summer, trip to French and Spanish Basque country.
1930	Appointment as Professor at the Düsseldorf Art Academy.
	Flechtheim Gallery exhibit shown at the Museum of Modern Art in New York.
1931	April 1, end of contract at the Bauhaus and assumption of teaching duties in Düsseldorf. Exhibit of 252 works at the North Rhine-Westphalia Art Society, Düsseldorf. Summer, second trip to Sicily.
1932	Trip to Venice via Bern.
1933	End of April, suddenly released from position at the Düsseldorf Art Academy. May 1, moves from Dessau to Düsseldorf. Short vacation on island of Port Cros near Toulon.
	December 23, emigrates to Bern.
1934	Meets E. L. Kirchner.
1935	First signs of illness: sclerodermia, triggered by measles. Exhibit of 273 works in Bern Kunsthalle.
1936	Takes cure in Tarasp and Montana.
1937	Picasso visits Klee in Bern.
	Klee is represented with 17 works in the German exhibition entitled "Degenerate Art." Convalesces on Beatenberg.
1939	Easter, Braque visits Klee in Bern.
	Fall vacation in Faoug on Murtensee.
1940	June 29, dies in the Clinica Sant'Agnese in Muralto-Locarno.
	Cremation in Lugano. July 4, funeral service in the chapel of the Burgerspital in Bern. The interment of Klee's ashes took place at the Schosshalde cemetery in Bern after the death of his wife Lilly in 1946.

Selected Bibliography

Writings by Paul Klee (in English translation)
"Creative Credo," in: *The Inward Vision*. New
York: Praeger, 1958.
The Diaries of Paul Klee, 1898-1918. Edited by
Felix Klee. Berkeley: University of
California Press, 1964.
On Modern Art. London: Faber and Faber,
1966.
*The Nature of Nature: The Notebooks of Paul
Klee, Volume II.* Edited by Jurg Spiller.
New York: G. Wittenborn, 1973.
Paul Klee: His Life and Work in Documents.
Edited by Felix Klee. New York: Braziller,
1962.
Pedagogical Sketchbook. New York: Praeger,
1953.
*The Thinking Eye: The Notebooks of Paul
Klee, Volume I.* Edited by Jurg Spiller. G.
Wittenborn, 1964.

Books
Geelhaar, Christian. *Paul Klee and the
Bauhaus.* Greenwich: New York Graphic
Society, 1973.
Giedion-Welcker, Carola. *Paul Klee.* New
York: Viking Press, 1952.
Grohmann, Will. *The Drawings of Paul Klee
(1921-1930).* New York: C. Valentin, 1944.
———. *Paul Klee: Drawings.* New York,
1960.
———. *Paul Klee.* New York: Abrams, 1967.
Haftmann, Werner. *The Mind and Work of
Paul Klee.* New York: Praeger, 1954.
———. *The Inward Vision: Watercolors,
Drawings, Writings by Paul Klee.* New
York: Praeger, 1958.